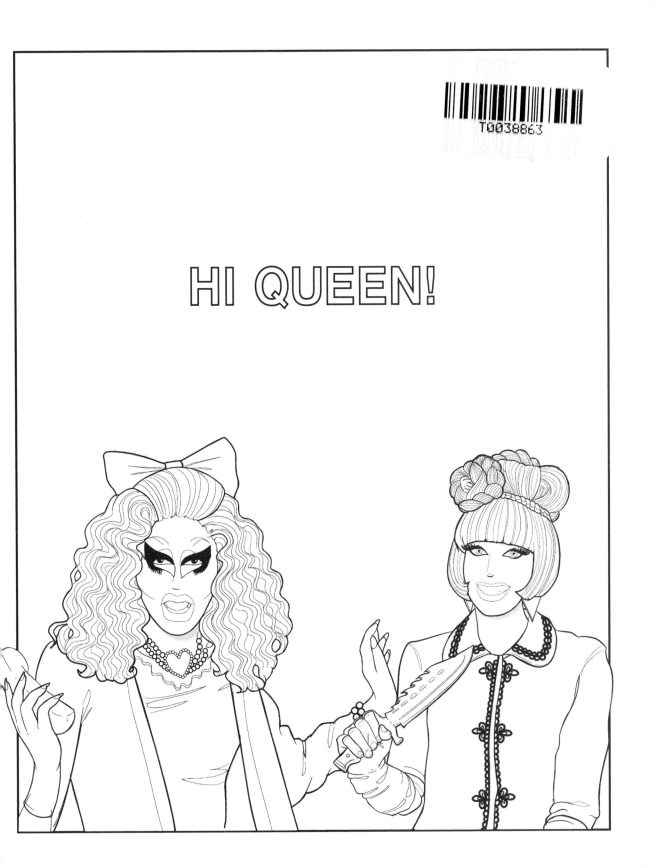

HI QUEEN!

The Official

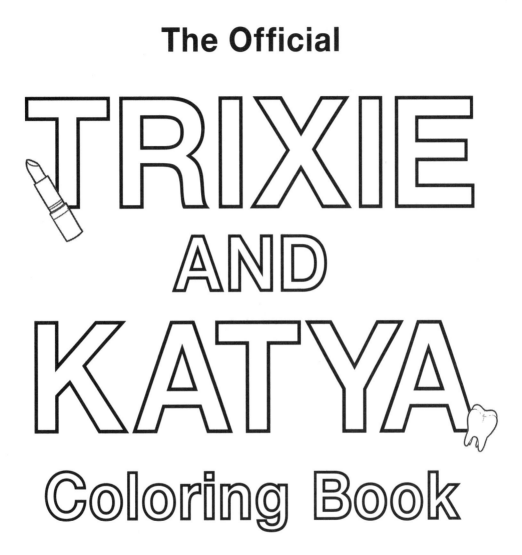

TRIXIE AND KATYA
Coloring Book

TRIXIE MATTEL AND KATYA ZAMOLODCHIKOVA
Illustrated by Aly Bellissimo

PLUME

PLUME

An imprint of Penguin Random House LLC
penguinrandomhouse.com

LIBRARY OF CONGRESS CATALOGING-IN-PUBLICATION DATA
has been applied for.

ISBN: 9780593473443 (paperback)

Printed in the United States of America
1st Printing

BOOK DESIGN BY SHANNON NICOLE PLUNKETT AND ILLUSTRATIONS BY ALY BELLISSIMO

THIS BOOK BELONGS TO

♡

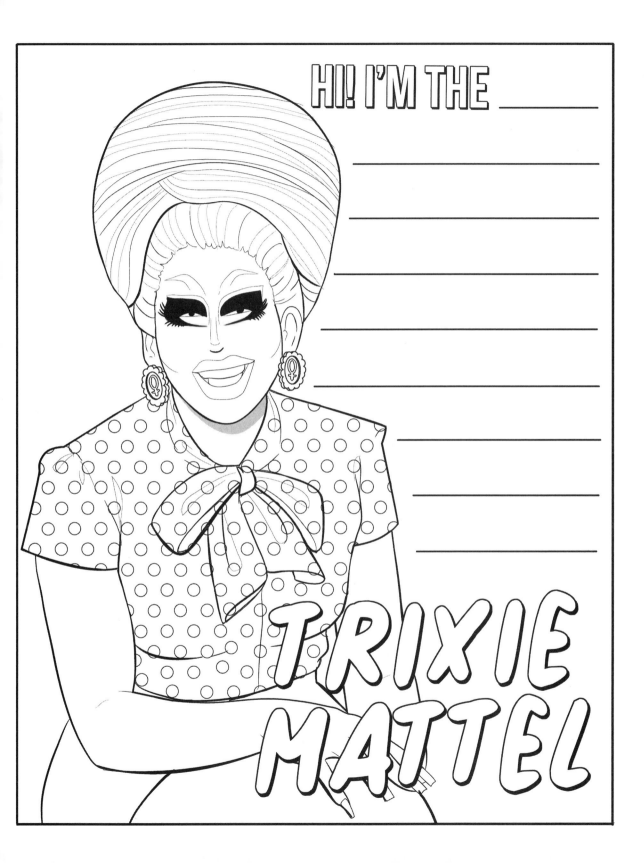

HI! I'M THE _____

TRIXIE MATTEL

AND I'M THE _____

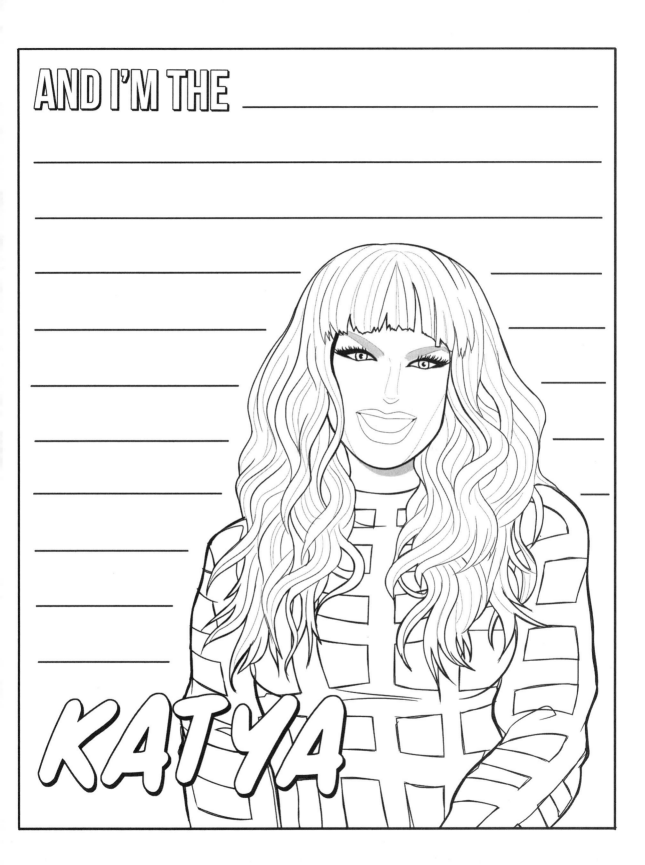

KATYA

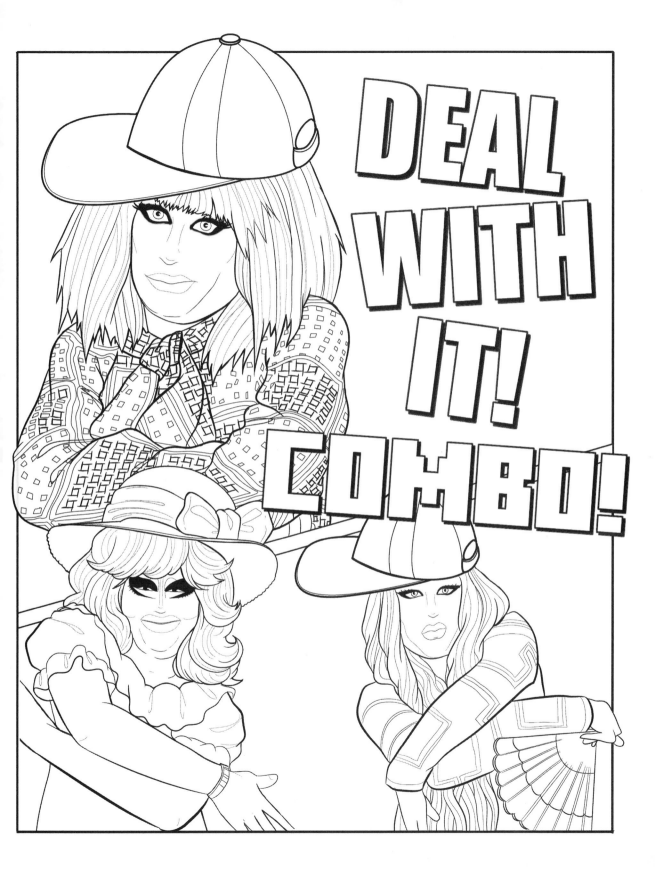

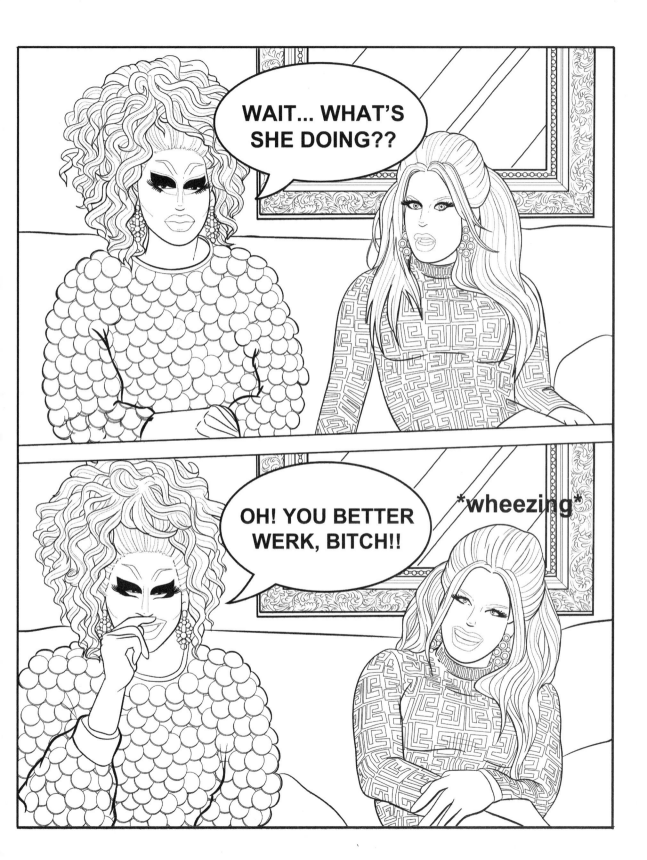

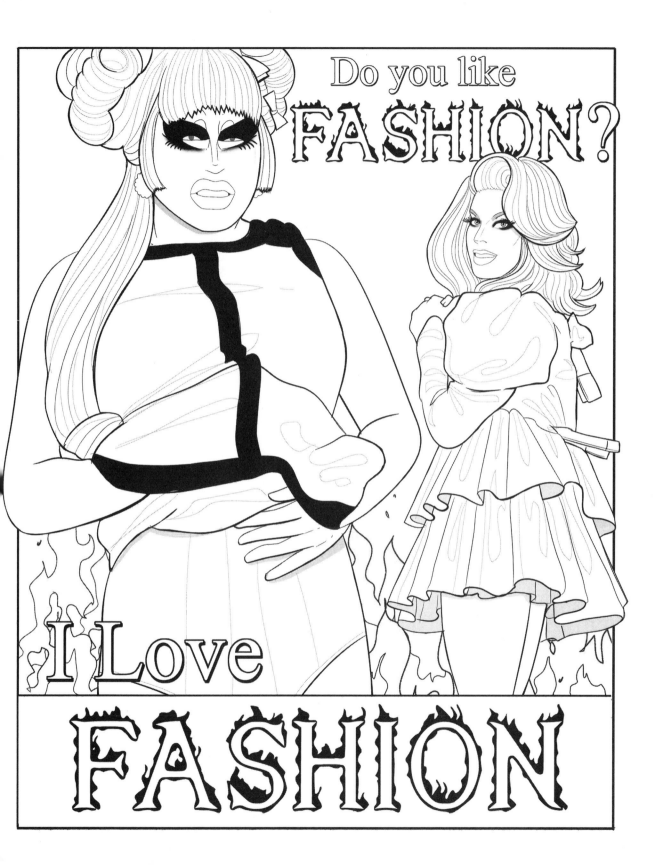

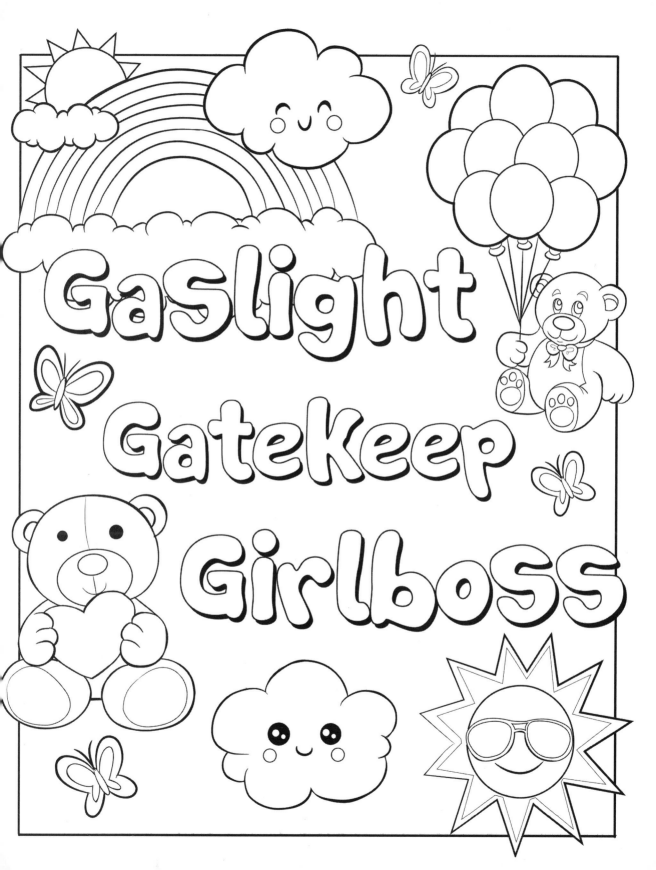

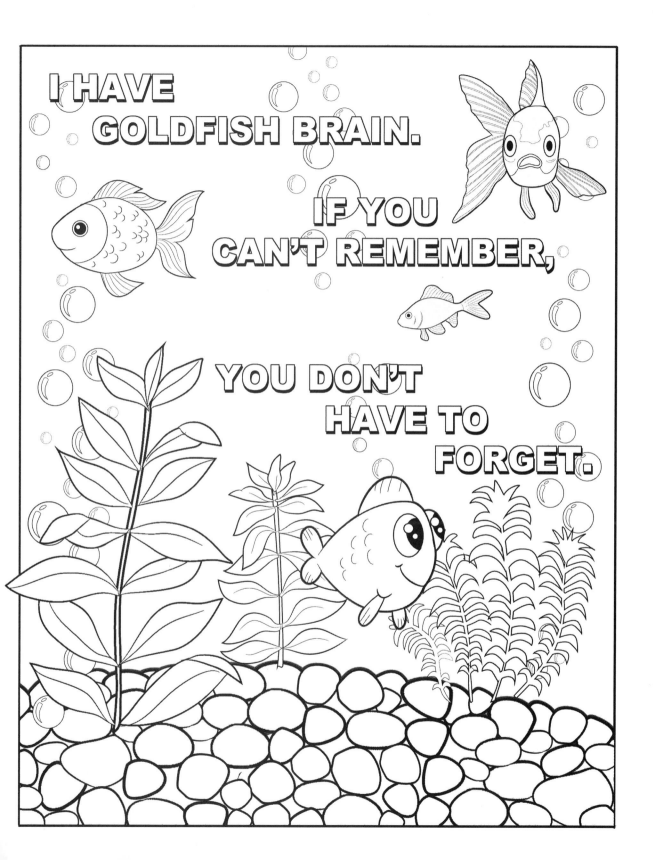

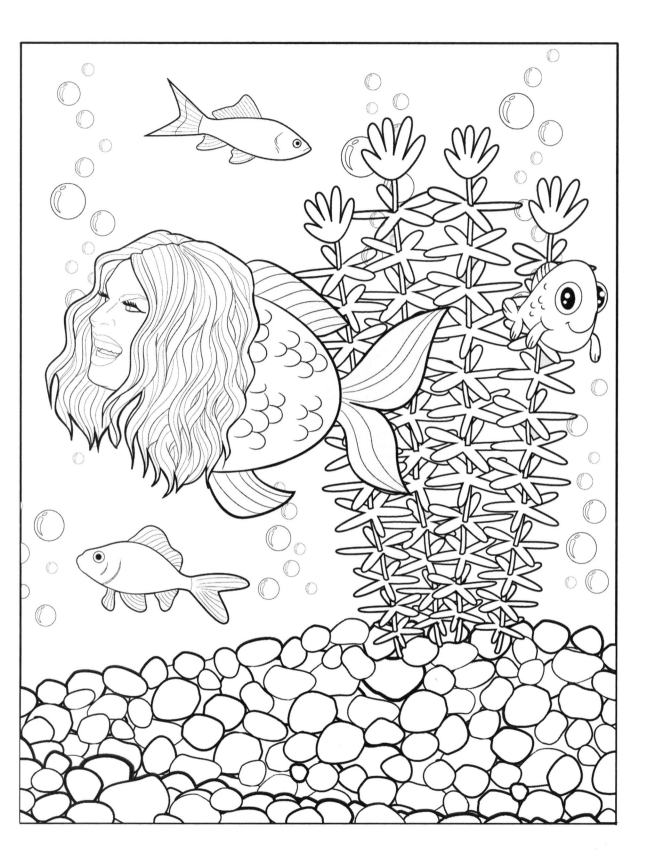

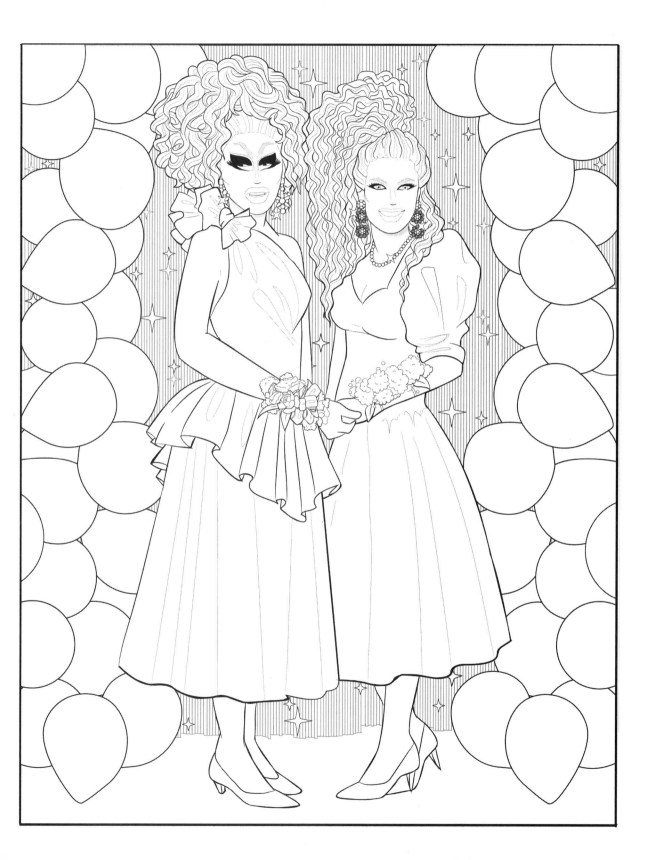

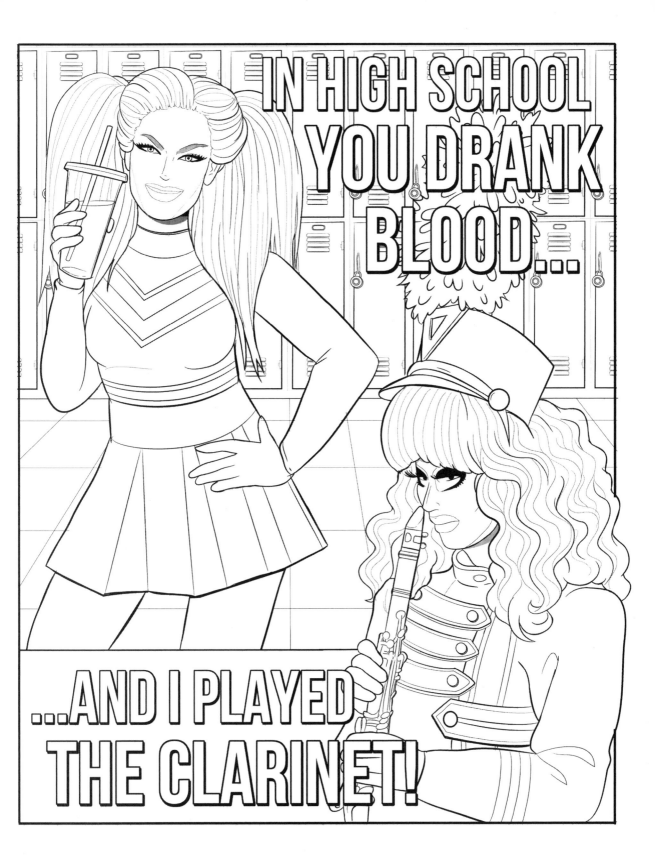

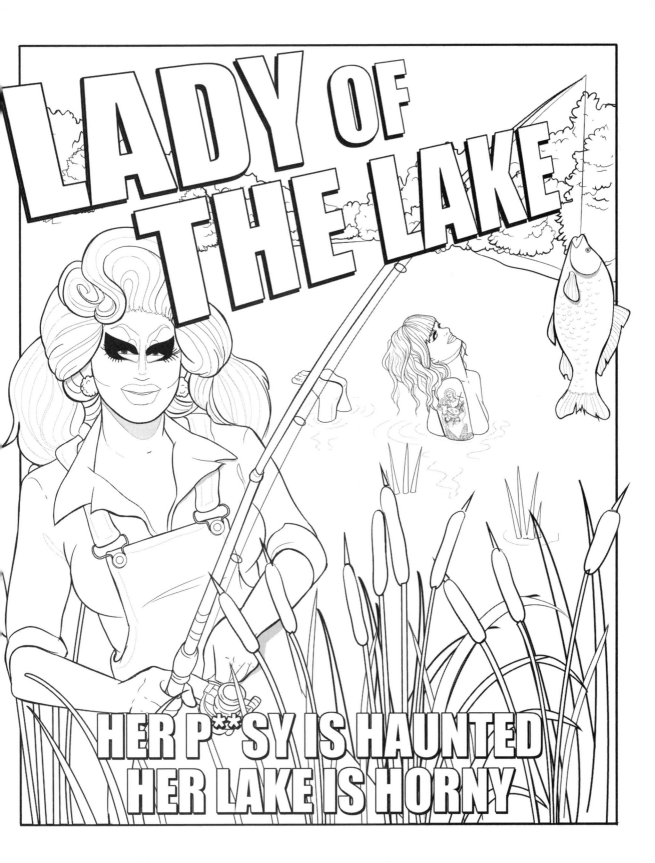

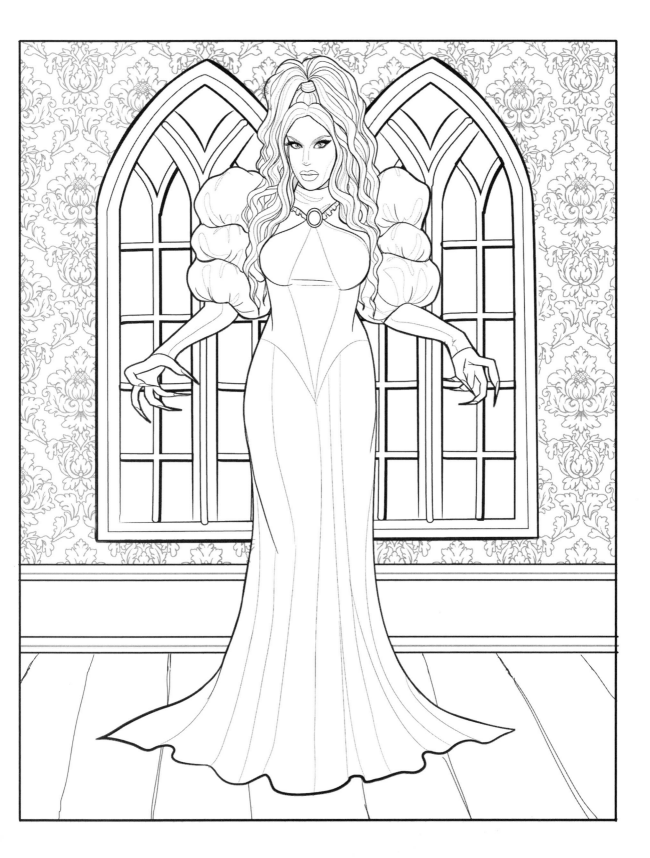

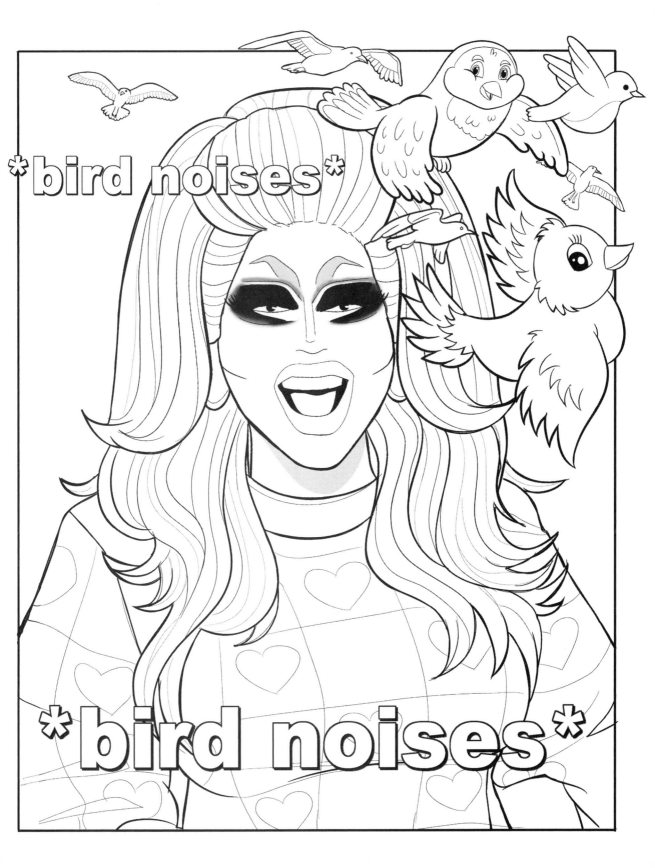

bird noises

bird noises

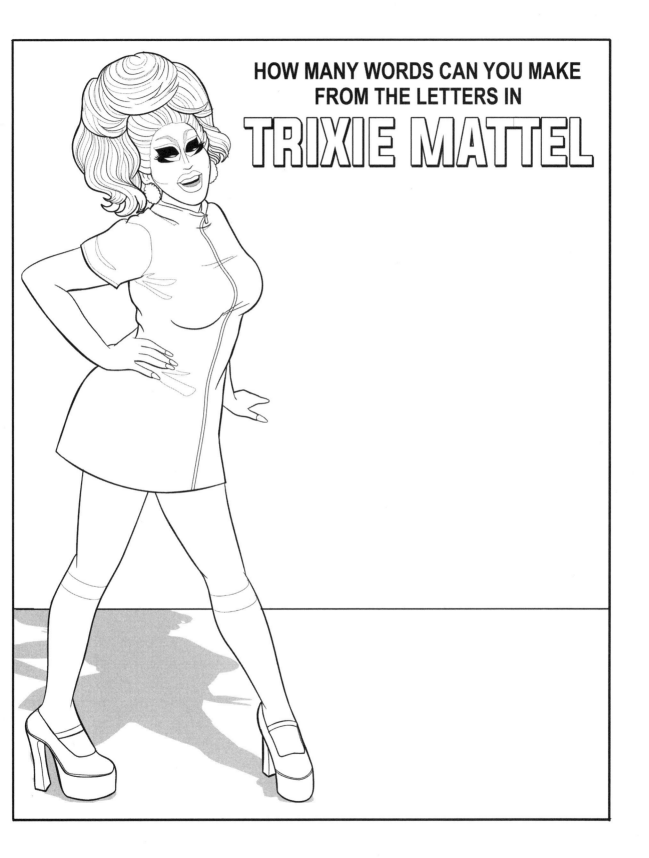

HOW MANY WORDS CAN YOU MAKE
FROM THE LETTERS IN
TRIXIE MATTEL

HOW MANY WORDS CAN YOU MAKE
FROM THE LETTERS IN
KATYA ZAMOLODCHIKOVA

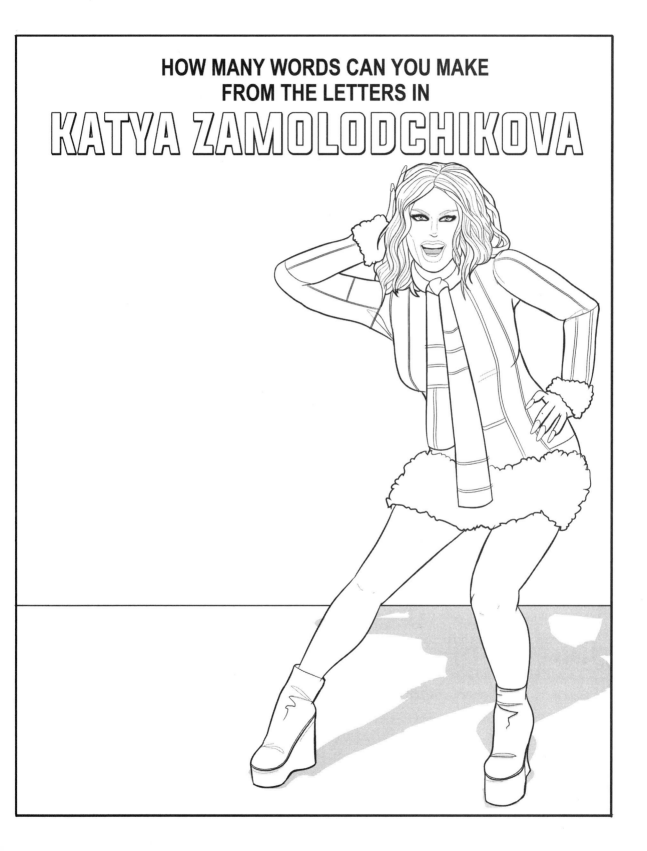

MATCH TRIXIE AND KATYA TO THEIR HOUSE, PET, AND CAR!

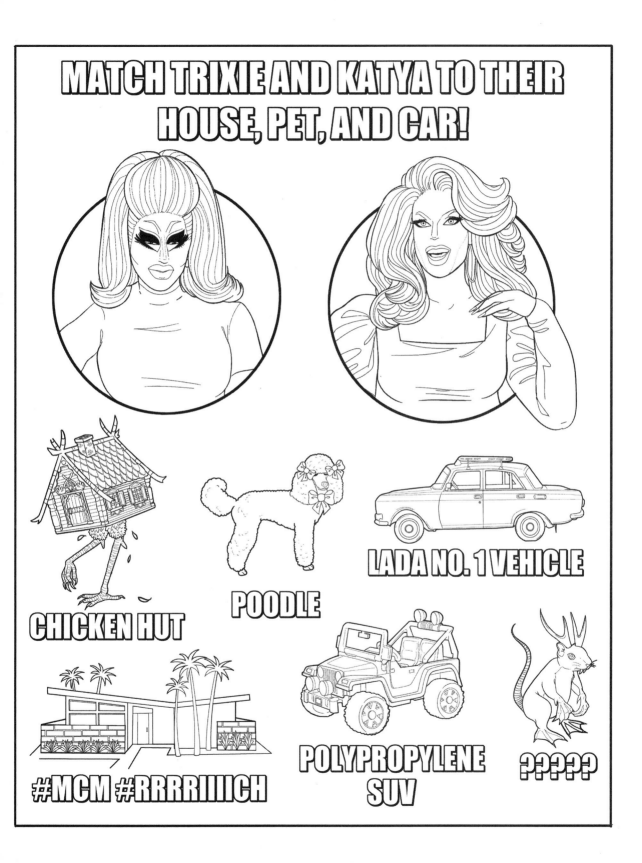

CHICKEN HUT

POODLE

LADA NO. 1 VEHICLE

#MCM #RRRRIIIICH

POLYPROPYLENE SUV

?????

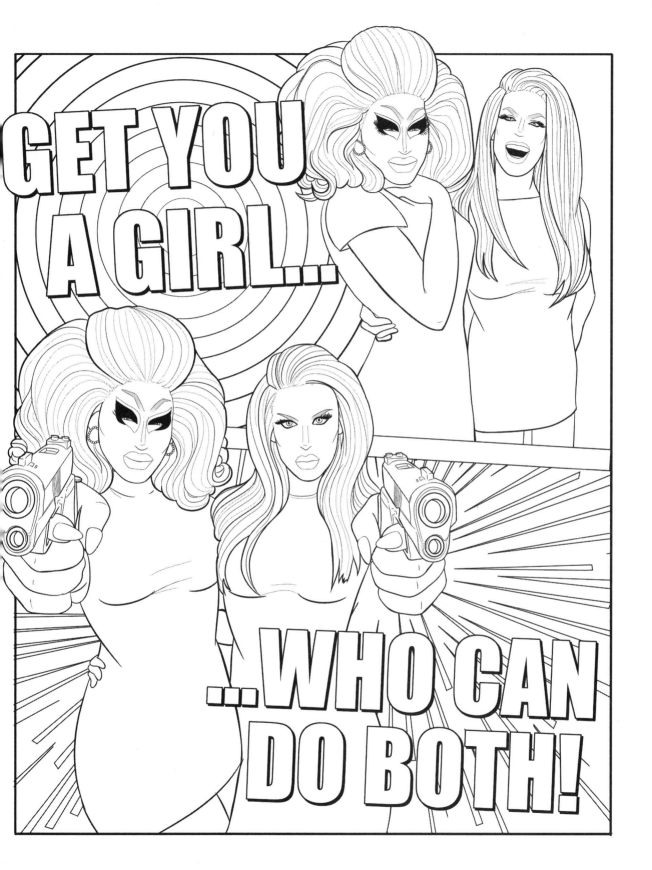

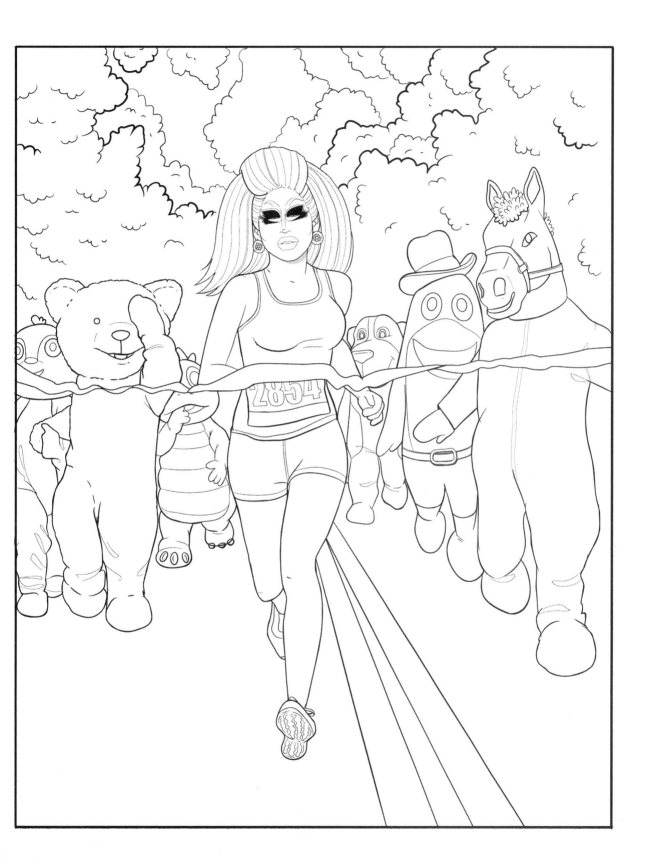

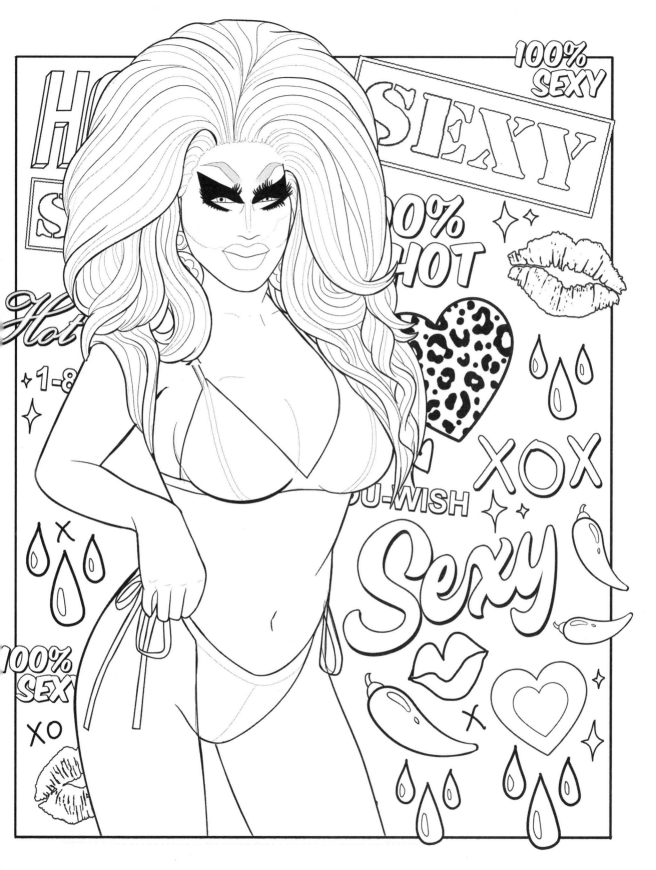

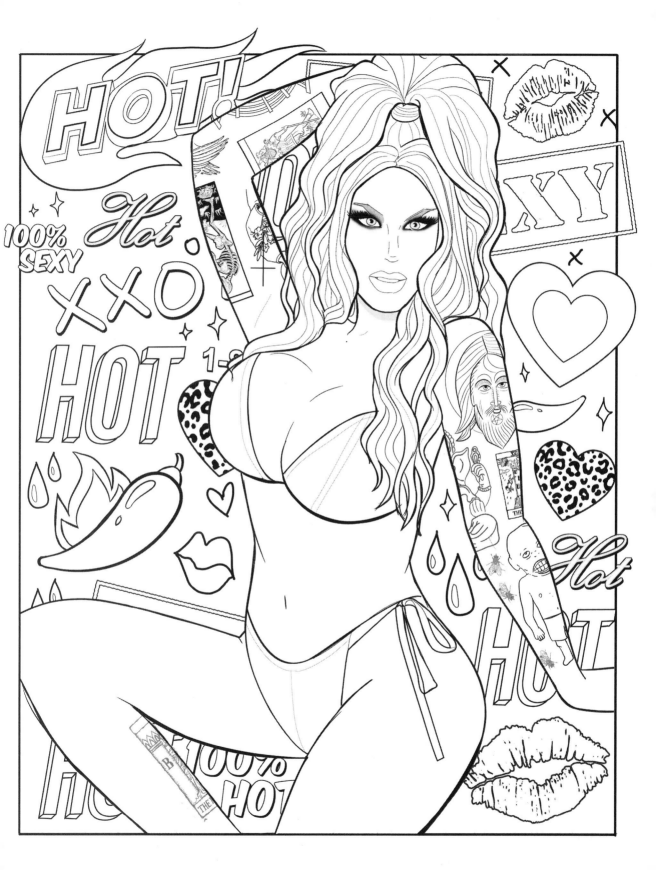

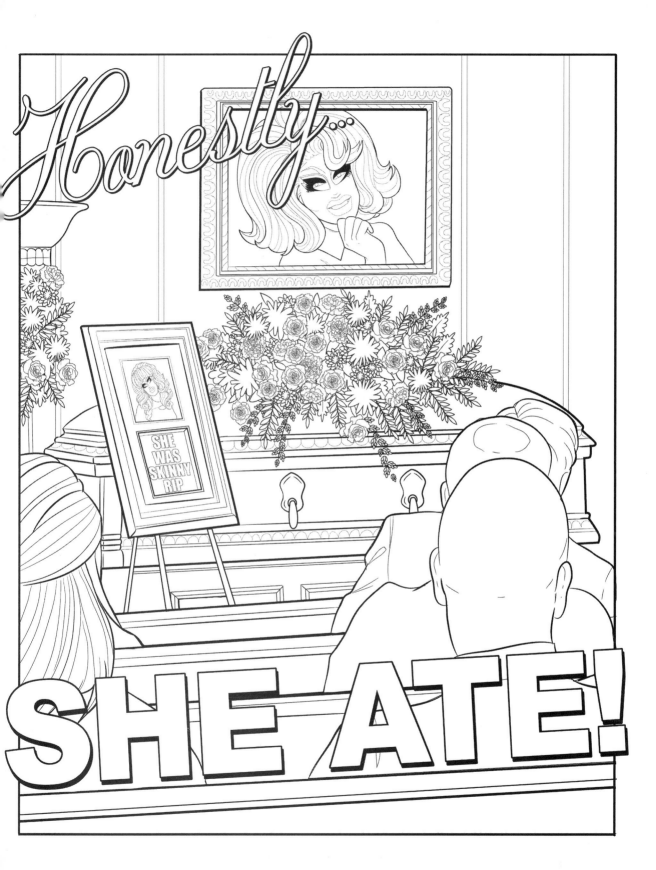

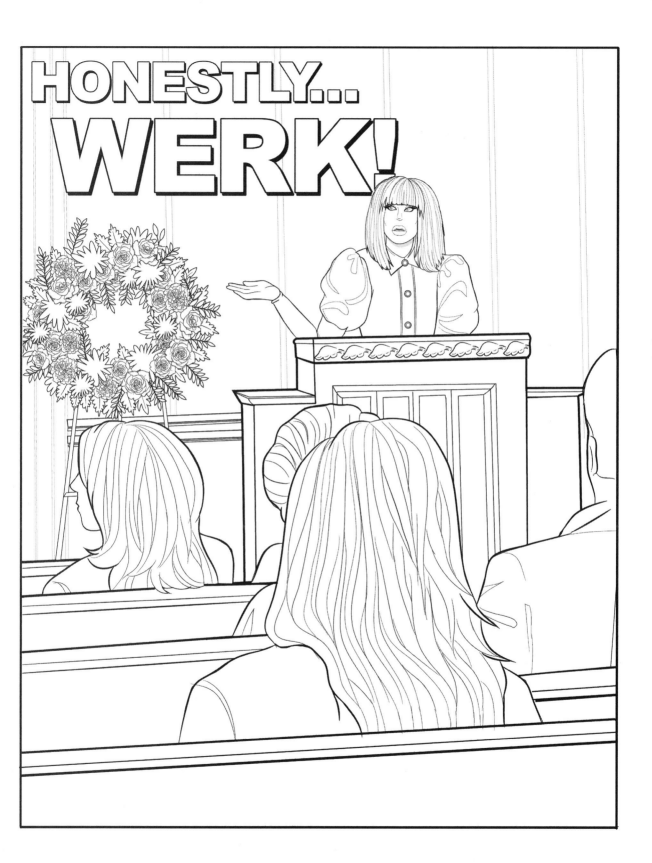

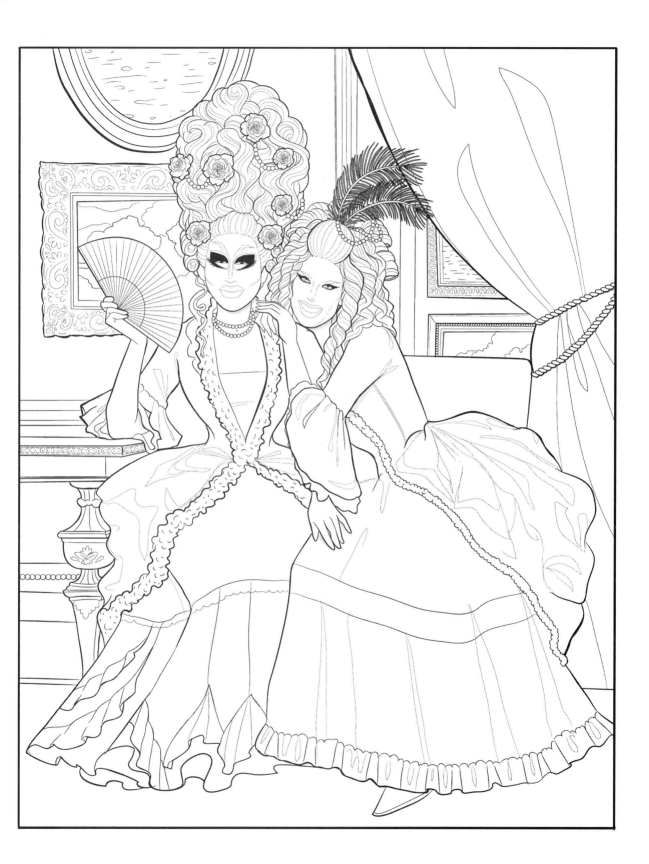

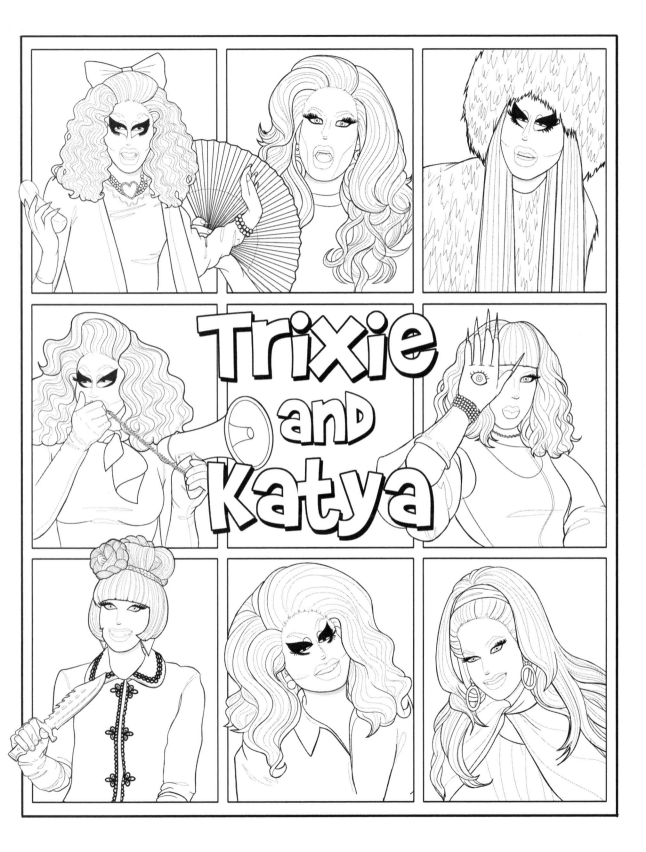

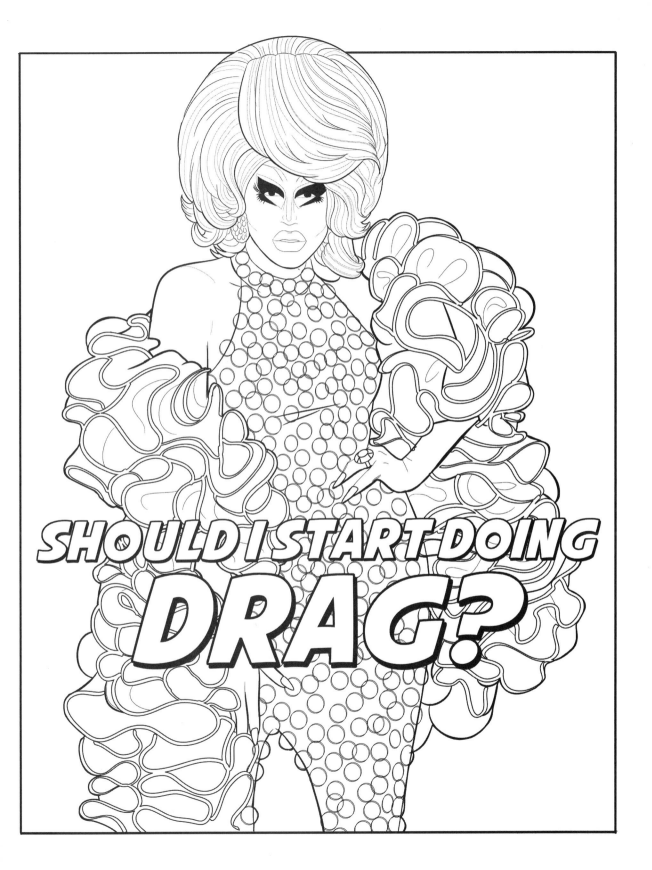

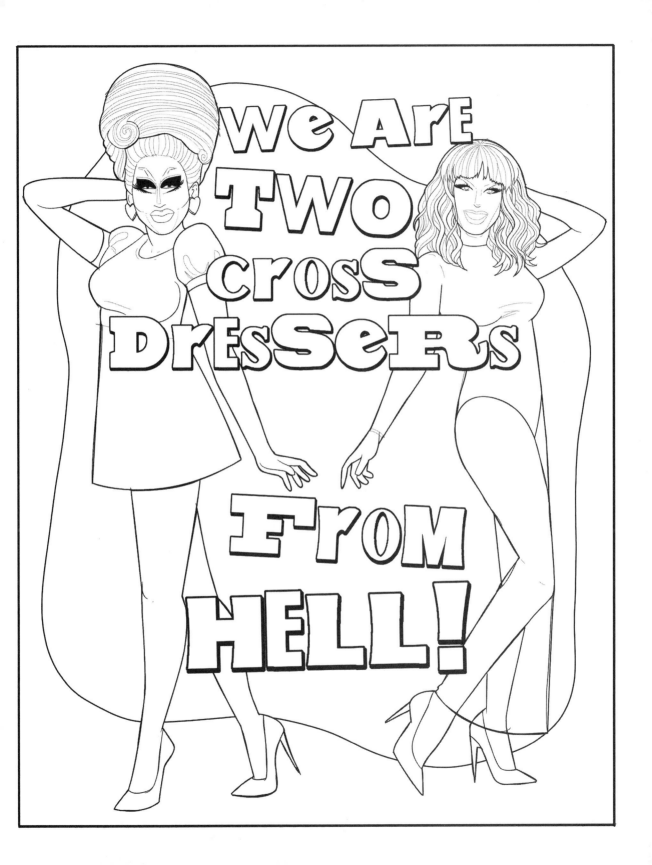

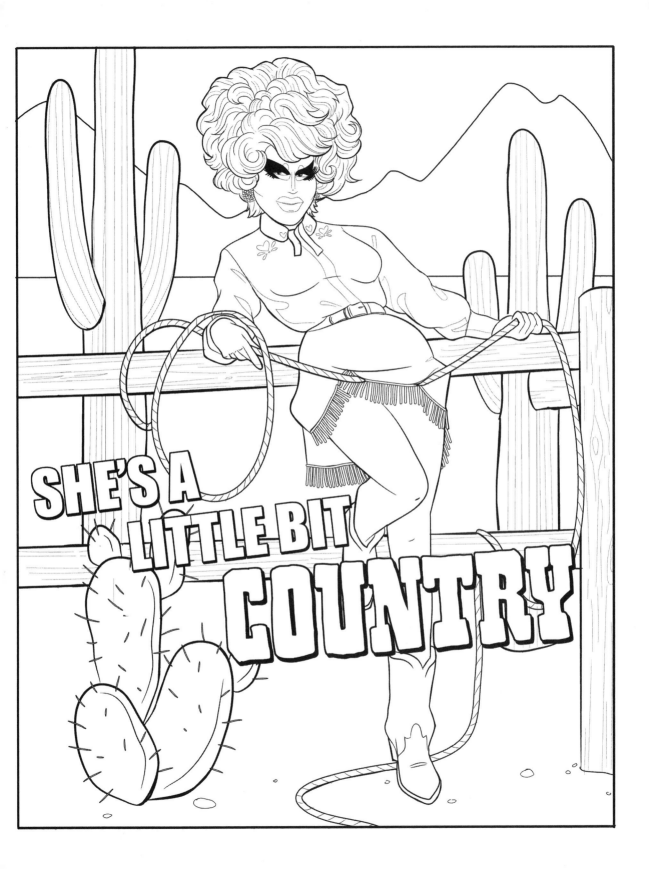

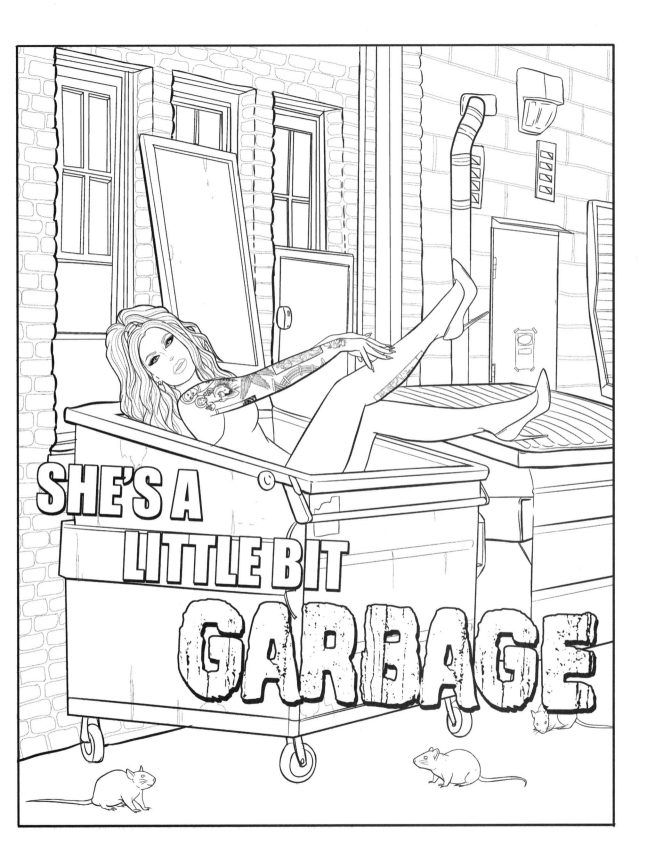

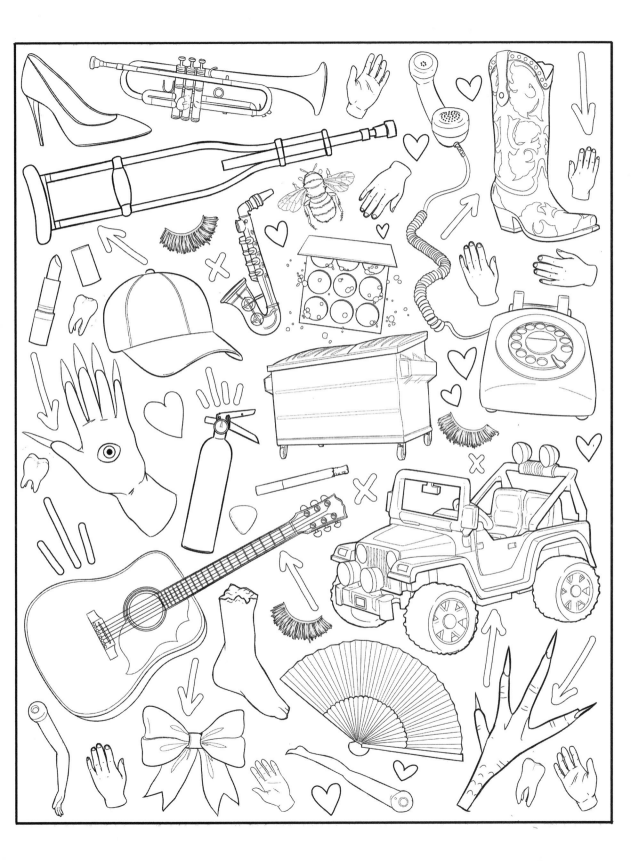

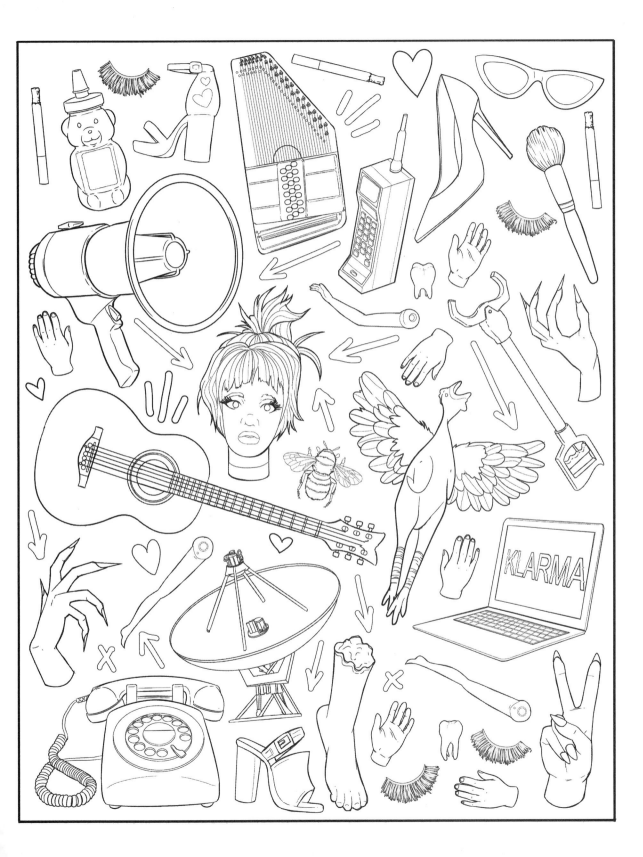

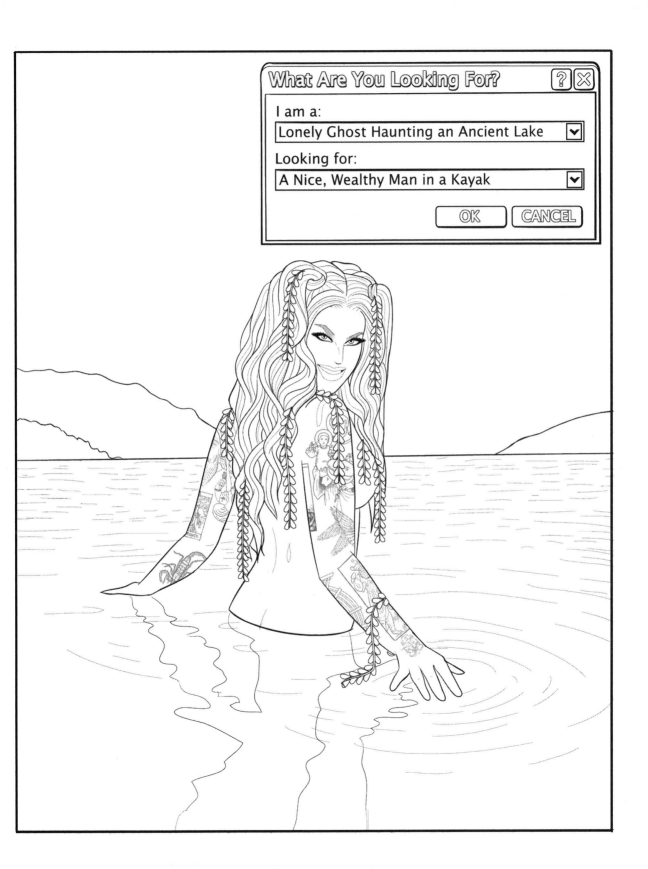

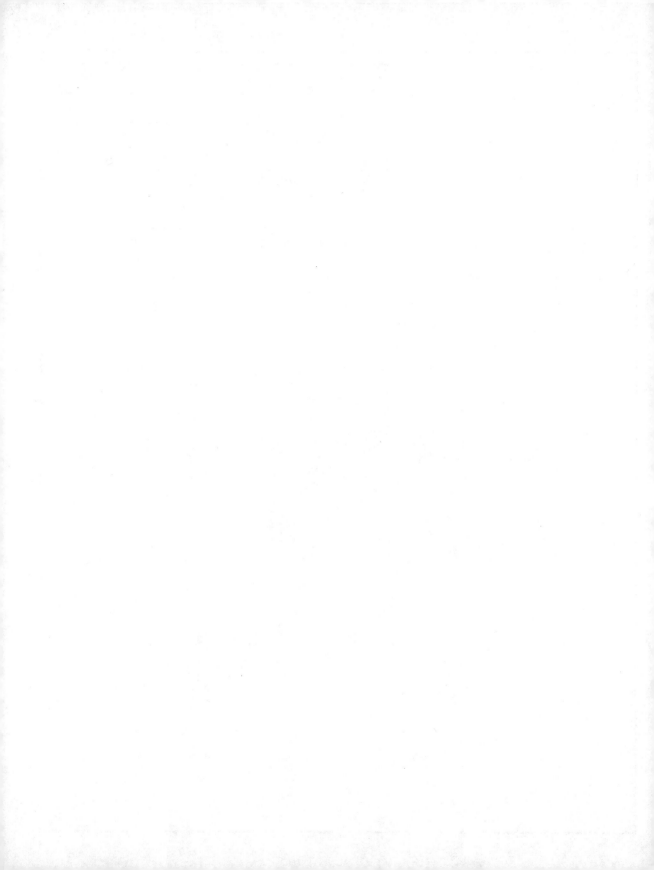

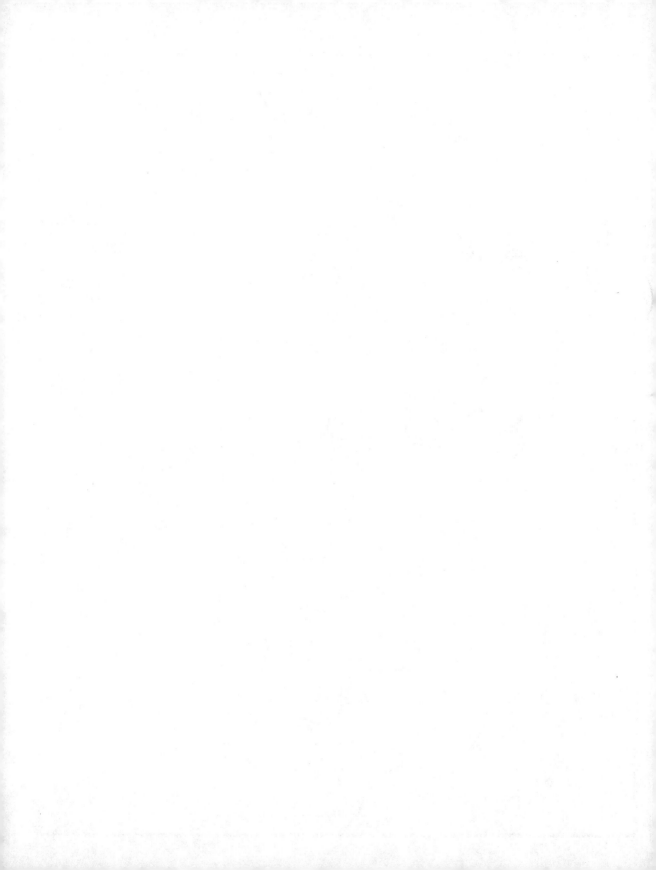

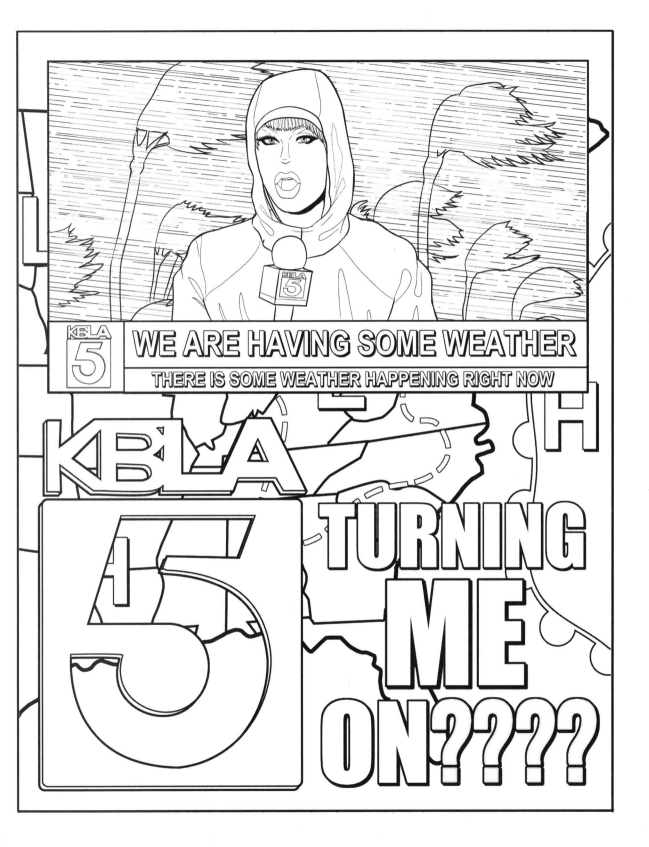

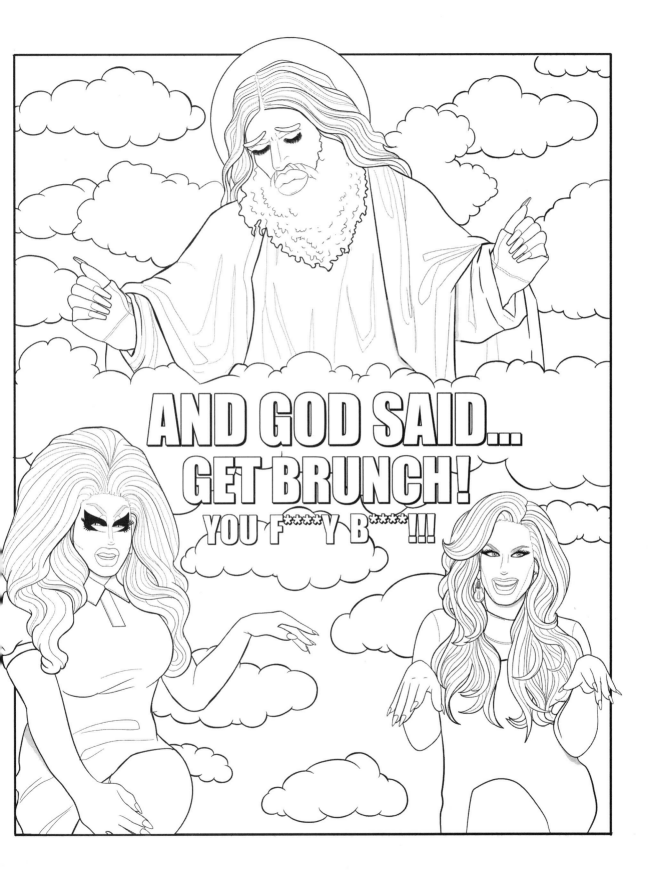

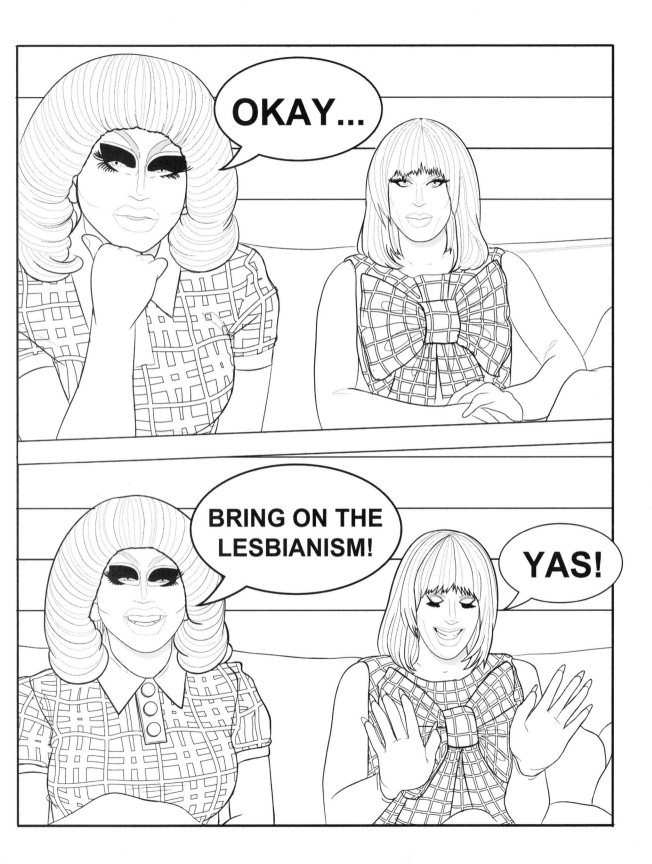

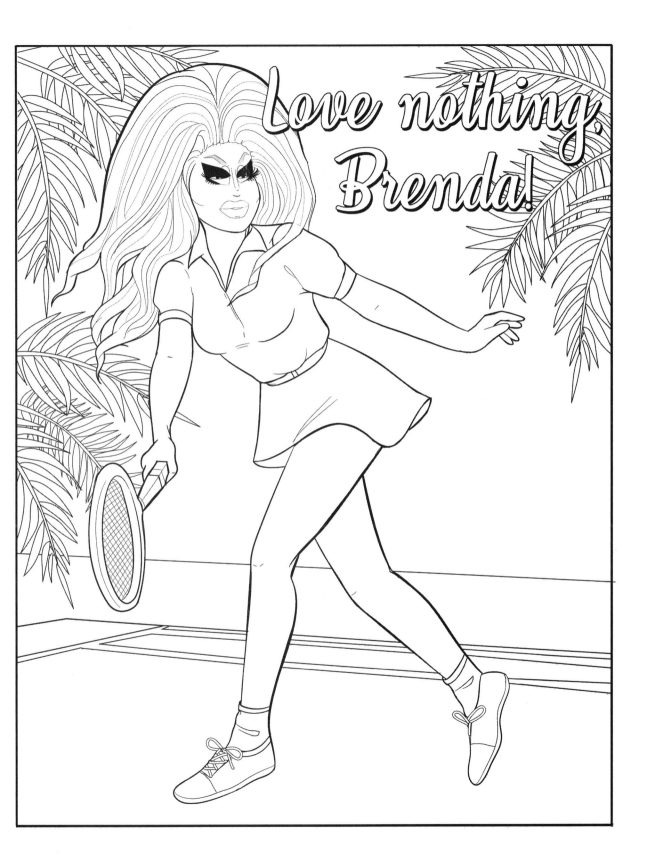

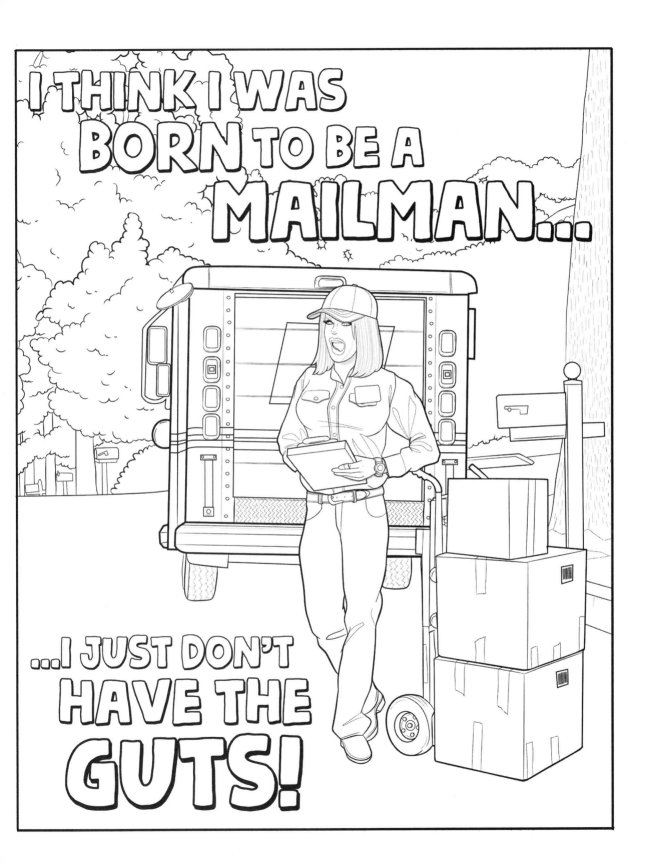

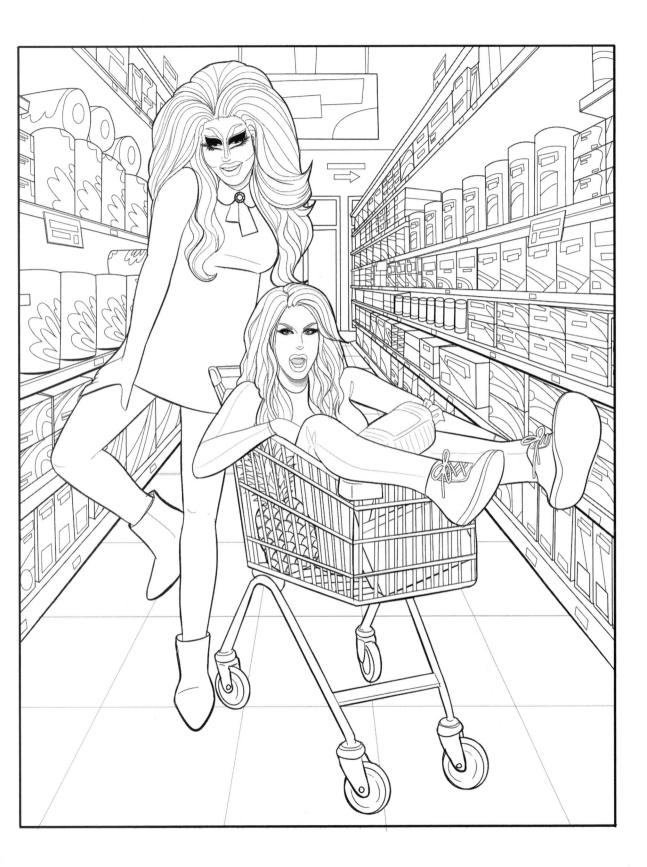

ABOUT THE AUTHORS

Trixie Mattel is a comedian, musician, cosmetics entrepreneur, bestselling author, DJ, and all-around thin woman. She is incredibly thin with bombshell curves in all the right places. She loves her partner, David, and tolerates all others.

Katya Zamolodchikova is a woman in her early forties looking to fall in love in the next three to five weeks. She lives in Los Angeles with her ex-husband, Glen, and her four beautiful daughters. This is her second book.

Aly Bellissimo is a real-life human woman born and raised in New York. When she's not working as an illustrator and graphic artist, she can be found eating olives, playing the bass clarinet, and wondering if her cat actually likes her.

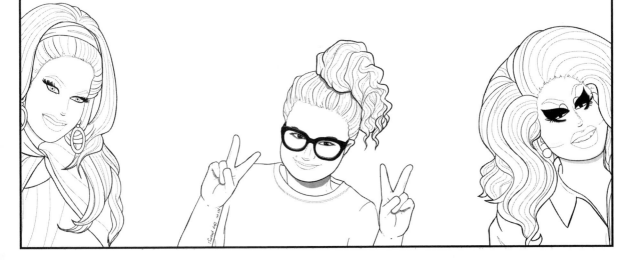